Waving Flags

black dog
publishing
london uk

05 *Image and Translation—Rut Blees Luxemburg*

Cast

08 Elisabeth Molin
13 Patrick Hough
17 Joanna Piotrowska
21 Masayo Matsuda
24 Clare Bottomley
29 *Looking at Andrei Rublev—Emily Butler*

Code

36 Abigail Sidebotham
40 Emma Charles
44 Victoria Jenkins
48 Julio Galeote
52 Geoff Bartholomew
56 *In Conversation with Antje Majewski*

Colony

60 Michal Bar-Or
64 Madoka Furuhashi
68 Simone Rowat
72 Taus Makhacheva
77 *In Conversation with Celine Condorelli*

Cuckoo

84 Ryan Moule
88 Louise Carreck
92 Oezden Yorulmaz
96 *Cuckoo—Olivier Richon*

Gebrochene Akkorde

102 Gao Shengjie
106 Beth Atkinson
110 Andrew Bruce
115 *Gebrochene Akkorde—Alexander García Düttmann*
117 Philipp Dorl

121 *Waving Flags—Nick Warner*

Image and Translation

Rut Blees Luxemburg

The starting point for the publication *Waving Flags*, is not a sinister semaphore, but a speculation on the relationship, that images have with translation. The quest to find a fitting translation for an idea or concept through a visual form is the challenge with which the artist must engage. Equally, a 'backwards translation' from the work of art to the unravelling of the ideas and intentions is comparably challenging.

Far from offering conclusions to the issues surrounding the notion of translation, the images and texts gathered in *Waving Flags* ask questions, which, if condensed into one persistent question might ask if there is an element in the work of art that stubbornly resists translation?

Reflecting on the potential and pitfall of translation, the artists in this volume named connecting conduits, that emerged in the initial and uncertain process of their work: *Code, Cast, Colony, Cuckoo* and *Gebrochene Akkorde*, a musical term, which translates into broken chords. Next they invited interlocutors to engage textually with those conduits, relating the concept of art and translation: the artists Celine Conderelli, Antje Majewski and Olivier Richon, the curator Emily Butler and the philosopher Alexander García Düttmann. The co-editor of *Waving Flags*, Nick Warner, provided an afterthought on translation and its relevance to the digital sphere.

The London-based practice The Entente designed *Waving Flags* in dialogue with the artists and editors and I wish to thank them for their collaborative approach as well as for their elegant design. I also thank the publication assistants Ryan Moule and Beth Atkinson for their dedicated help and support and Nick Warner whose dramaturgical and critical input helped to shape an expansive perspective.

I thank the Royal College of Art and Black Dog Publishing for making it possible to bring together such an engaged group of artists, writers and designers, whose contributions to the question of the image and translation could not be more diverse and involving.

Cast

I asked the night guard if I could take his picture.
He said, Can I take yours?
We talked about panoptic prisons and about photography.
I noticed that his eyes were red, that he looked tired.
He showed me the photograph and asked me how to
get rid of the red eye effect.

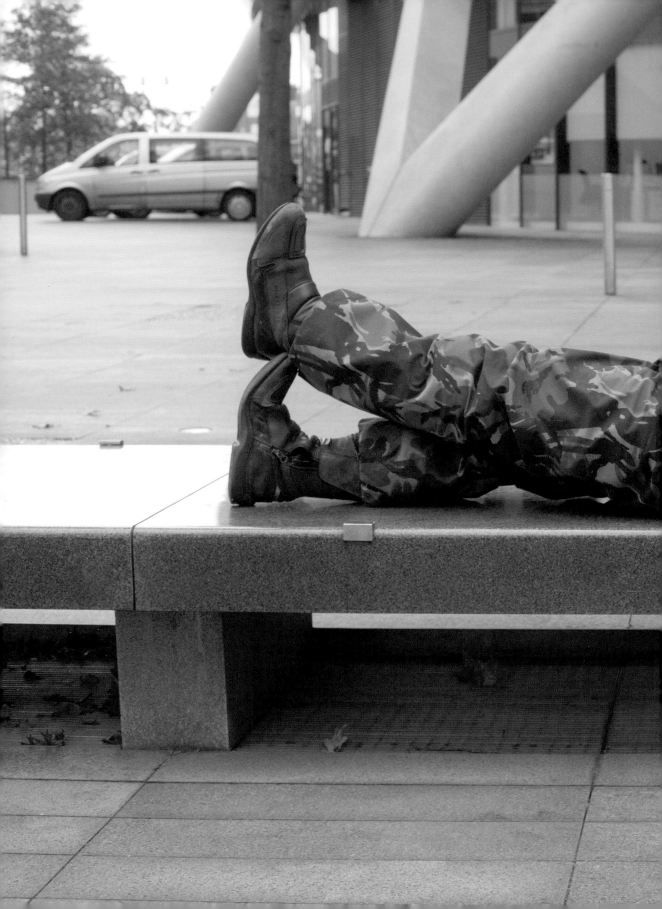

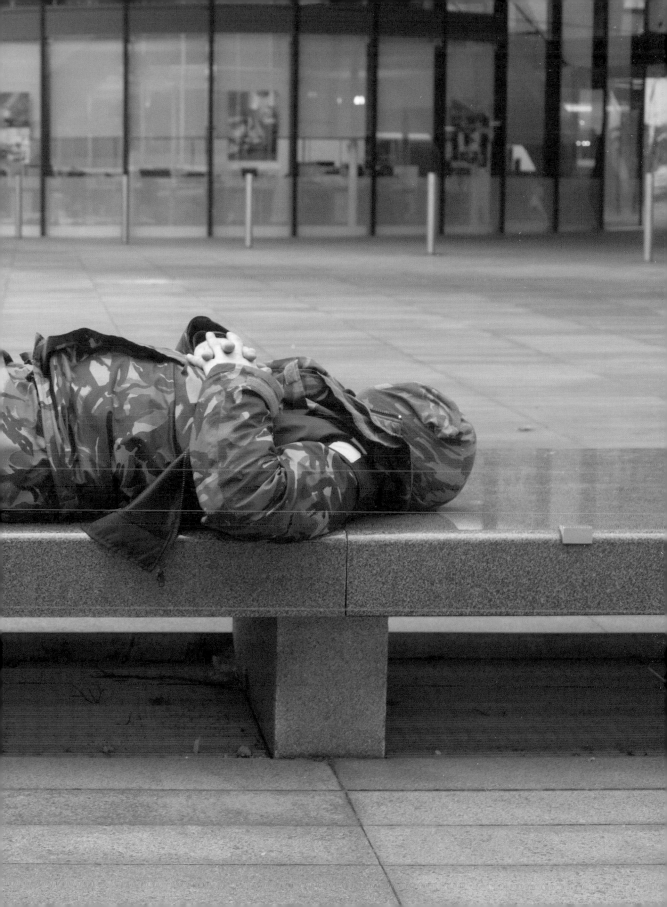

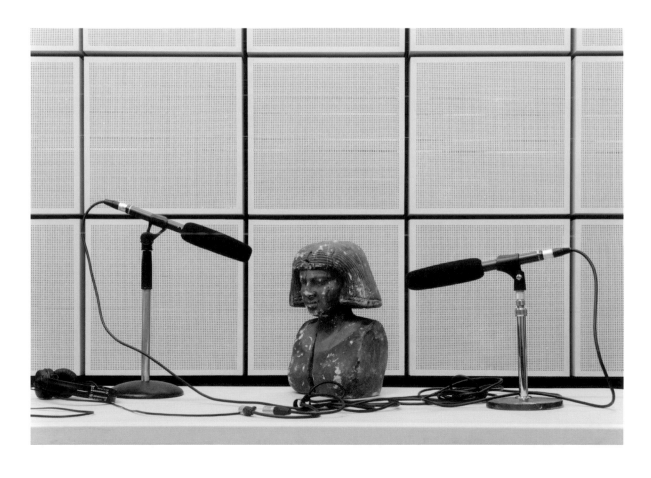

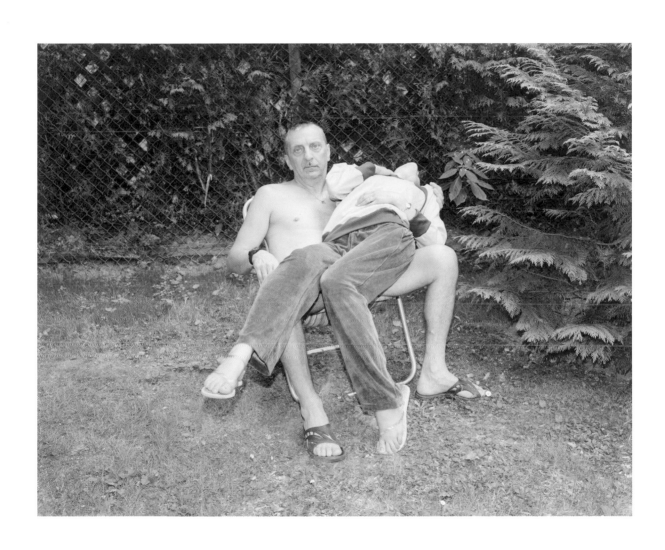

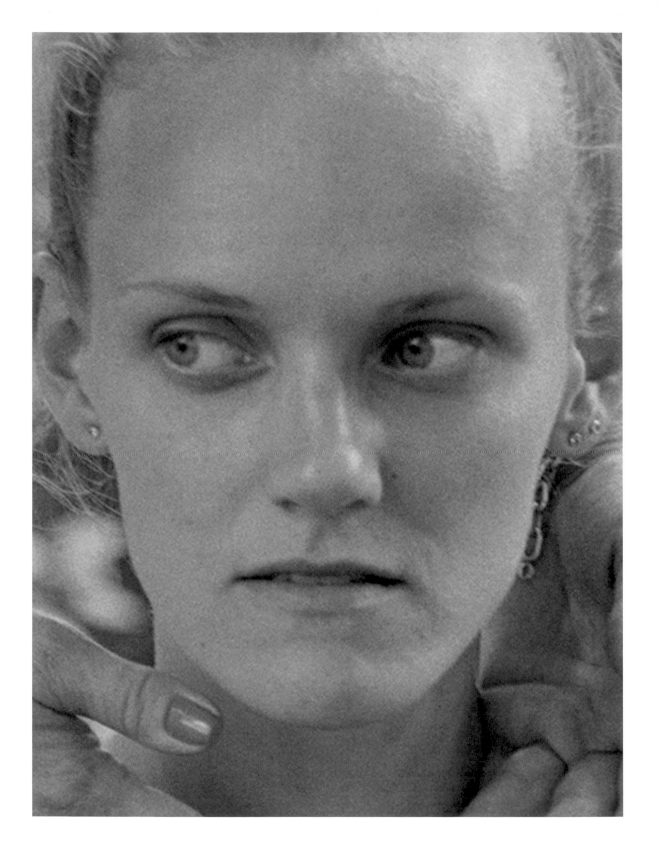

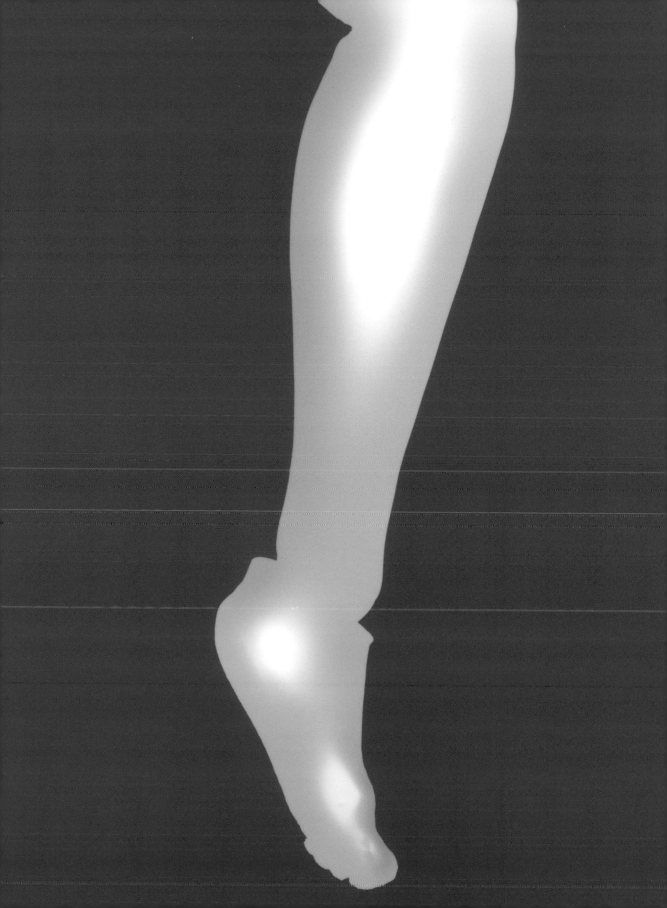

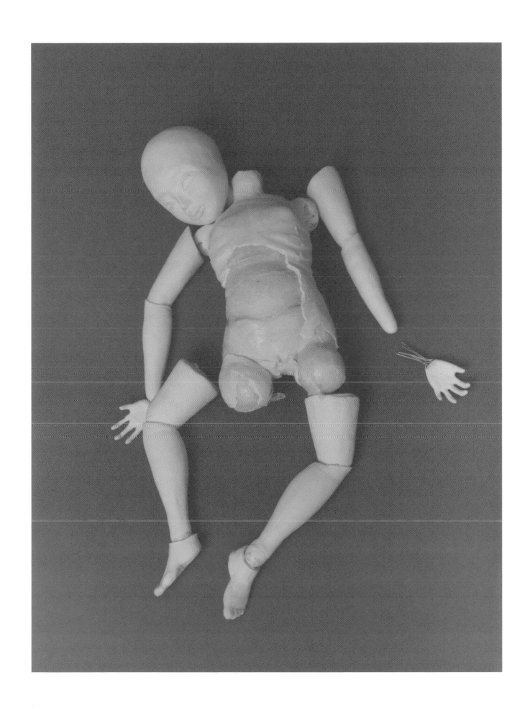

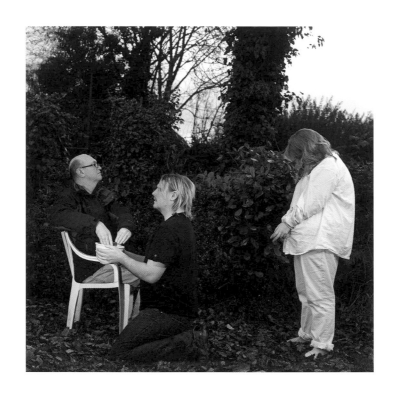

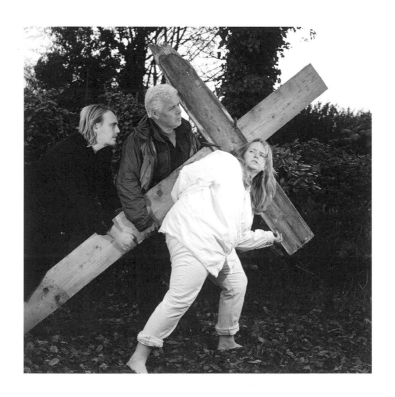

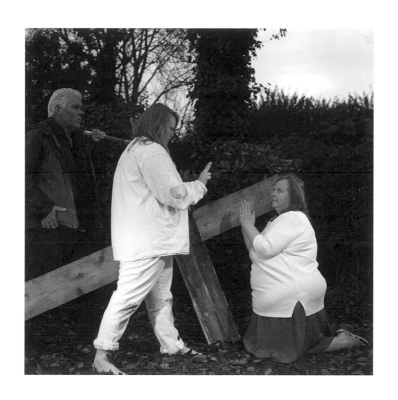

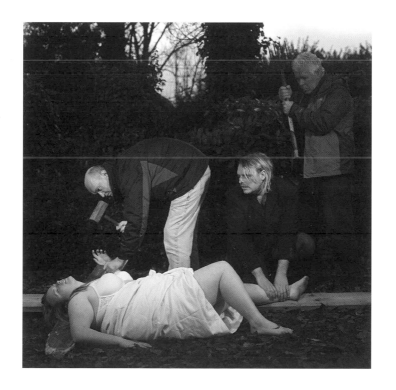

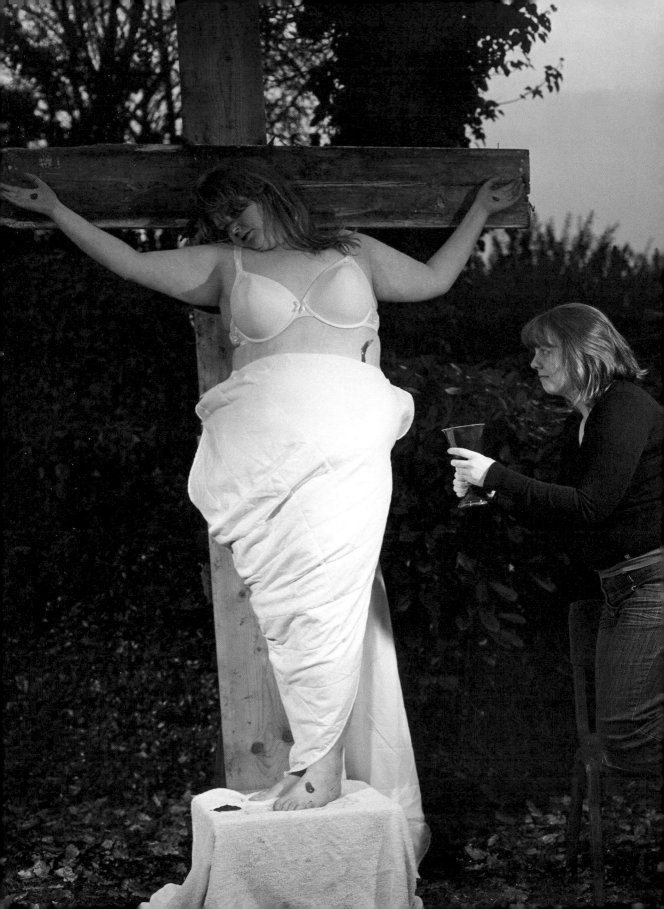

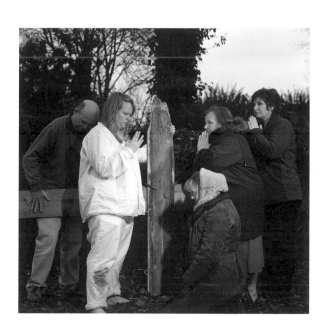

Looking at Andrei Rublev

Emily Butler

1. The camera follows a group of men walking on a ridge overlooking a fortified Medieval Russian city. Labourers start digging a large pit in which a giant church bell will be cast, bird's eye view. Then, from a close-up of a teenager's face, the camera gradually pans out over the scene which now looks like a Bruegel winterscape as a small army of workmen reinforce the pit and build kilns. Later, this same slow outward panning will reveal the bell hoist ropes extending like tentacles out into the landscape, as the bell founding literally takes over the town.

The final scene in Andrei Tarkovsky's film, *Andrei Rublev*, 1966, the casting of a large bronze church bell, is the culmination of a filmic meditation on the subject and purpose of knowledge in relation to artistic practice. The film portrays artistic or more generally human experience in Medieval Russia, through several vignettes, which loosely use icon-painter and national hero Andrei Rublev's life as a guiding thread. Although the film received a stunted reception during Tarkovsky's early career due in part to Russia's secular authorities, it has received extensive critical acclaim ever since thanks to its complex and multi-layered structure and aesthetic. Indeed *Rublev* can aptly be seen as a metaphor for Tarkovsky's own creative enquiry, but also a reflection on the purpose of art more generally as its discursive use of history maintains its contemporary relevance.

The film raises questions that Tarkovsky felt were central to artistic practice both in Medieval times but also for contemporaneous artists. What is the purpose of an image? What makes an image iconic? How can an image be imbued in faith or represent truth? What is knowledge; how is it acquired? Does the image serve the individual, power or God? Its use of various chapters of Russian history shows the conflicting forces that were to taunt Rublev: violence, famine, temptation, yet at no point in the film are solutions offered to respond to these threats. What's more, unlike other artist biographies such as the earlier portrayal of Van Gogh by Vincente Minnelli in *Lust for Life*, 1956, or *Edvard Munch* by Peter Watkins, 1974, Rublev's daily experiences are separated from his practice, allowing the

works themselves to appear in the final minutes as free-floating images, enhanced by being the film's only colour sequences. In this way there seems to be no clear illustration of a sense of progression of Rublev's art or personal style. Characters struggle with conflicting emotions, and self-doubt within prescriptive social boundaries, and there is little comprehensible narrative. The film therefore raises important aesthetic or existential dilemmas but does not proffer solutions. *Rublev* employs a dialectical method of portraying the world; protagonists are bound between their everyday experiences and their quest for knowledge, caught between what they see and what they believe.

Dialectical tension can perhaps be seen most clearly in the final scene, where Rublev witnesses the casting of the bell for the town of Vladimir. Traditionally, bell founding in Medieval Russia was a large task involving extraordinary resources. The film charts the digging of the giant pit to house both the clay cast of the bell and to withstand the pouring of several hundred kilos of molten alloy required to cast the bronze. A young teenage character Boriska has been charged with supervising the works by the Grand Prince, since further to the death of his family and father, a master founder, he claims to hold the 'secret' or knowledge of bell casting. Although at the inception he appears confident in front of the Prince's men and the foremen, we come to notice the conflict between his assurance and self-doubt as works on the bell progress, and his gradual mental exhaustion in having to drive the task at hand. As viewers we are increasingly uncertain that the project will be pulled off.

The purpose of the build up of tension in the bell-casting scene is to demonstrate that artistic truth or knowledge lies in a careful balance between observation and imagination. Indeed, at the end of the film, once the bell has been cast and rung we discover that Boriska actually did not have the bell founding 'knowledge'. How did the young boy manage to have the confidence, the authority and faith in himself to carry off the project? No doubt he had *seen* his father cast bells and knew the basic steps to do so. But how did he know what particular clay to choose for the mould, how many layers could withstand the pour, how best to hoist the bell, was this by instinct? This begs the question as to whether the situation in which Boriska was operating—the common labourers, the founders with whom he was working, all working towards a common aim—actually carried the project? That the conditions in fact moulded the project? Or to what extent did Boriska's faith, instinct and imagination mean that he was able to drive the collective effort towards success?

2. Bell founding has not fundamentally changed much since the Middle Ages; both then and now, it requires skilled craftsmen able to fine-tune this complex manufacturing process and to transmit its art. The significant resources needed for casting bells were well beyond those employed by Rublev for example to paint panels, iconostasis or frescoes, his artistic media. Tarkovsky therefore seems to have chosen a mightier art form to put Rublev's practice into perspective. When casting bells in Medieval times

however, there would have probably been little room for experimentation with what was a technically perilous and highly expensive activity. Its chances of success no doubt depended on so many variables, that chance and faith must have played an important role in its success. Tarkovsky emphasises this throughout the scene; in crucial moments in the casting process, through close-up shots, Boriska is seen to pray for providence to be on his side.

Bronze casting requires the use of both positive and negative moulds. Traditionally a false bell is first produced—a positive—and a cope or hood with images or inscriptions—a negative mould—is placed over the false bell. The negative space between the cope and the false bell is thus cast or filled to produce the bell. Positive and negative, as formal restrictions, can both be seen thus to mould and to delimit the bell. Although Tarkovsky undertook two years of meticulous research in advance of filming, it is interesting to note that while *Rublev* contains details of certain aspects of bell casting, it avoids depicting the modelling stages. Instead, it chooses to focus on the creation of the mould, or moulding process. We see the founders throwing clay in order to create what is presumably the outer mould or cope. We never see the false bell or the template that might have been used to create it. Is this a method of maintaining suspense, concealing the form of the bell until it is unveiled? Or a metaphorical choice that focuses on Boriska as a catalyst for creativity, on his role in moulding the project using talent, intuition and faith, instead of being *moulded* by tradition as part of the machinery of a mighty collaborative casting effort?

These formal opposites, the processes of casting versus moulding, the use of positive and negative moulds, the contrast between Rublev's art and bell casting, are in keeping with the dialectical nature of the film. In many ways, Tarkovsky's oppositions are still as relevant nearly 50 years on. As he stated himself: "The work of art lives and develops, like an other natural organism, through the conflict of opposing principles. Opposites reach over into each other within it, taking the idea out into infinity."[1]

3. Tarkovky's film offers a meditation on creativity, set in a specific historical context. However, its aim is not to faithfully re-enact Rublev's life or specific events at the time that he was living. On the contrary as we have seen the editing of the bell-casting process for example enabled Tarkovsky to enhance its dramatic effect. Furthermore, by using naturalistic acting, wide angles, and lengthy close-up of the characters' faces, we are meant to feel their conflicting and complex experiences in order to empathise with them. The purpose of this empathy, in keeping with the dialectical nature of the film, was to allow viewers to attempt to grasp a shared sense of 'reality', since for Tarkovsky the "past is far more real, or at any rate more stable, more resilient than the present".[2]

[1] Tarkovsky, Andrei, *Sculpting in Time: Reflections on the Cinema*, trans. Kitty Hunter-Blair, Austin: University of Texas Press, 1986, p. 47.

[2] Tarkovsky, *Sculpting in Time*, p. 58.

Chris Marker incisively commented in his biographical documentary on Tarkovsky, *One Day in the Life of Andrei Ansenevich*, 1999: "This film on Russia and the Middle Ages is the only true film about our era." Indeed, Tarkovsky uses *Rublev* to investigate Russian identity both past and present through the life of one of its national heroes. The country is portrayed as a repressive society in all its harsh realism as Medieval rinces or landowners have authority of life or death on their subjects, whist at the same time being at the mercy of foreign invasion. Although the parameters have changed, by using historical material Tarkovsky is able to reflect on ever-current issues such as the relationship between authority, power and knowledge. In his quest for reality, Tarkovsky uses the mirror of history to reflect contemporary concerns.

In addition to using history as a symbolic tool, Tarkovsky often described cinema as an *impression of time* on the cinematic reel. His cinematography was an attempt to sculpt the 'lump' that is time as: "Assembly, editing, disturbs the passage of time, interrupts it and simultaneously gives it something new. The distortion of time can be a means of giving it rhythmical expression. Sculpting in time!"[3] This attempt to manipulate time, by enhancing its dynamism or fragmented nature, by moulding and casting the 'lump' of time, is the foundation of cinema according to the filmmaker. Tarkovsky simultaneously uses time as a material, so is bound by its parameters, but he also moulds time, by manipulating our perception of it.

The formal and conceptual approach to time and history in Tarkovsky's film completes his dialectical approach. Tarkovsky's cinematography, like Rublev's art, aims to reveal the 'truth'. Yet *Andrei Rublev*'s strength lies in the fact that it cannot easily be deciphered. It is a discursive and dynamic work, a cinematography that embraces film's coinciding linearity and fragmentation. Ultimately, the tensions between the themes we have examined—seeing and knowing, casting and moulding, the historical and the present—the space between these poles allows me, as a viewer to read or to translate his work through my imagination.

[3] Tarkovsky, *Sculpting in Time*, p. 121.

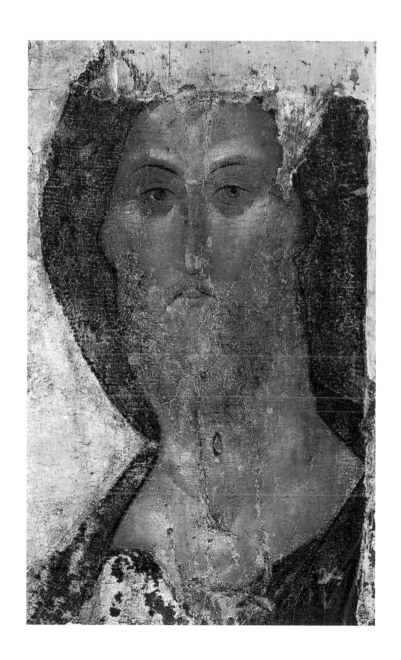

Code

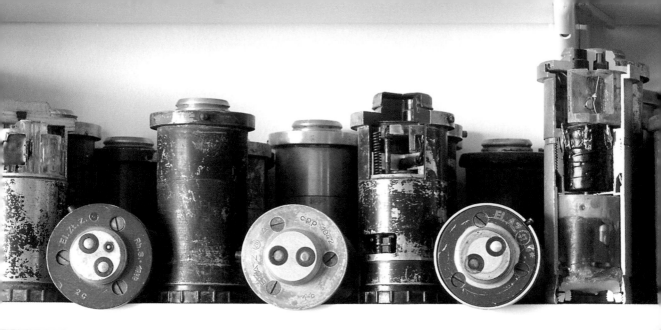

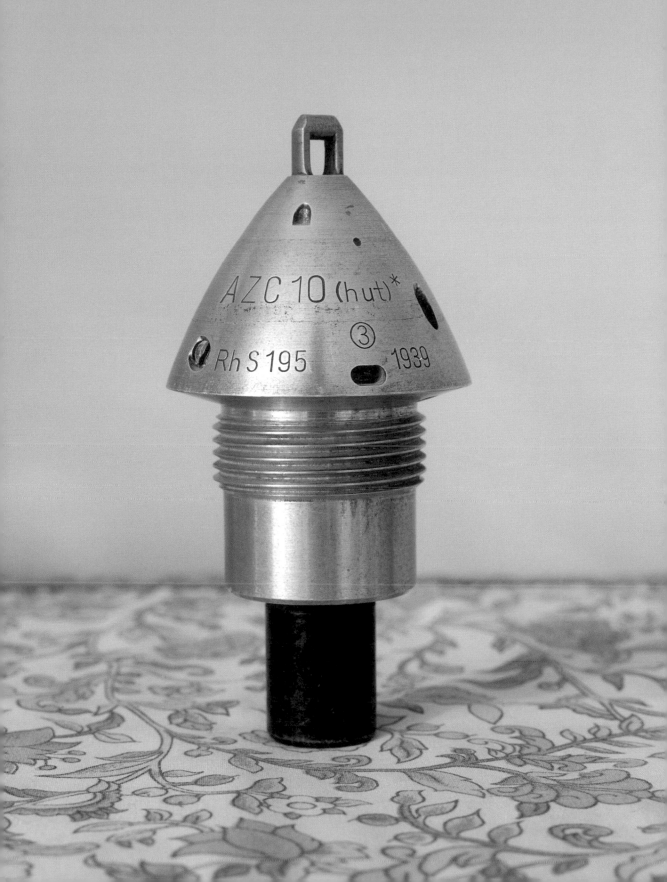

BBid Price

BATS Bid

0:03 26 10:00:03 52 10:00:03 78 10:00:03 104 10:00:03 130 10:00:03 156 10:00:03 182

zes for eLEN.B on 07/23/2010

BATS Bid

208 10:00:03 234 10:00:03 260 10:00:03 286 10:00:03 312 10:00:03 338 10:00:03 364 10:00:03

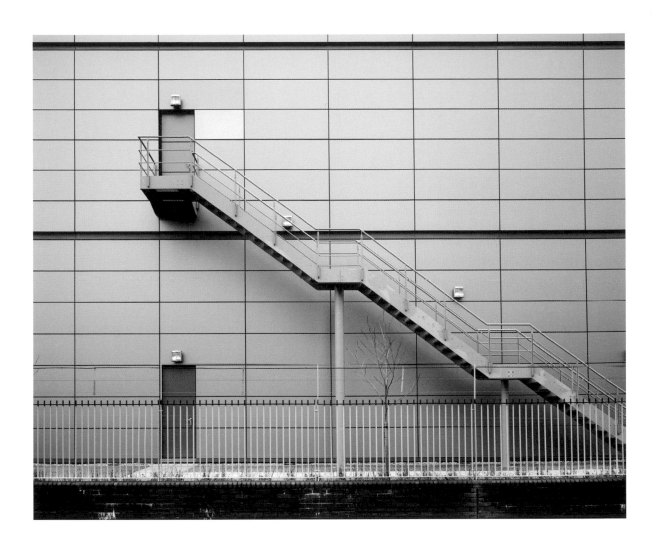

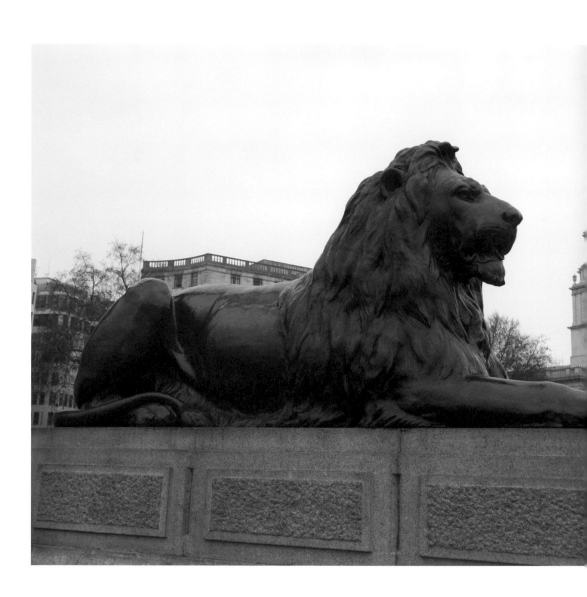

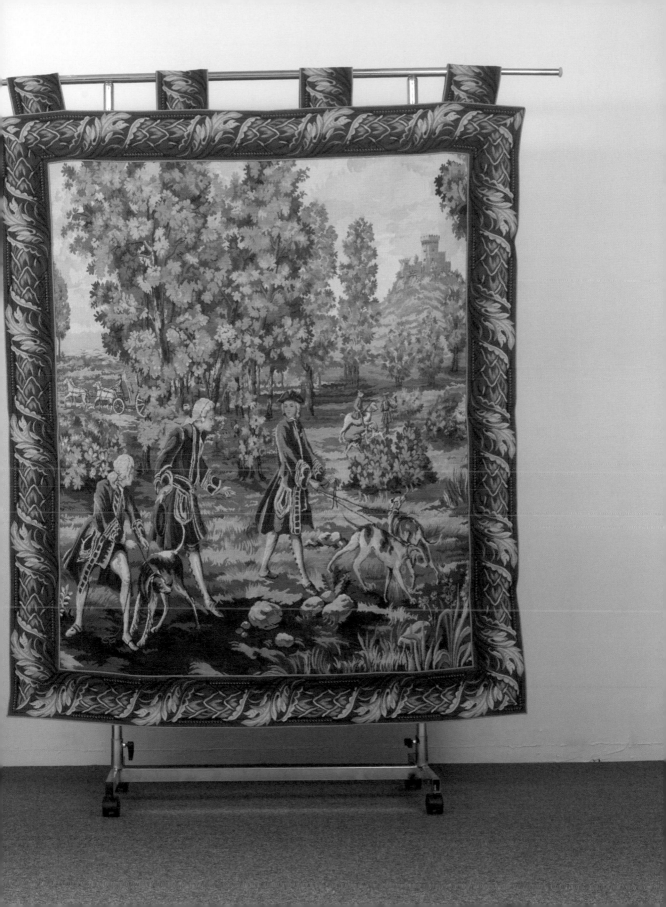

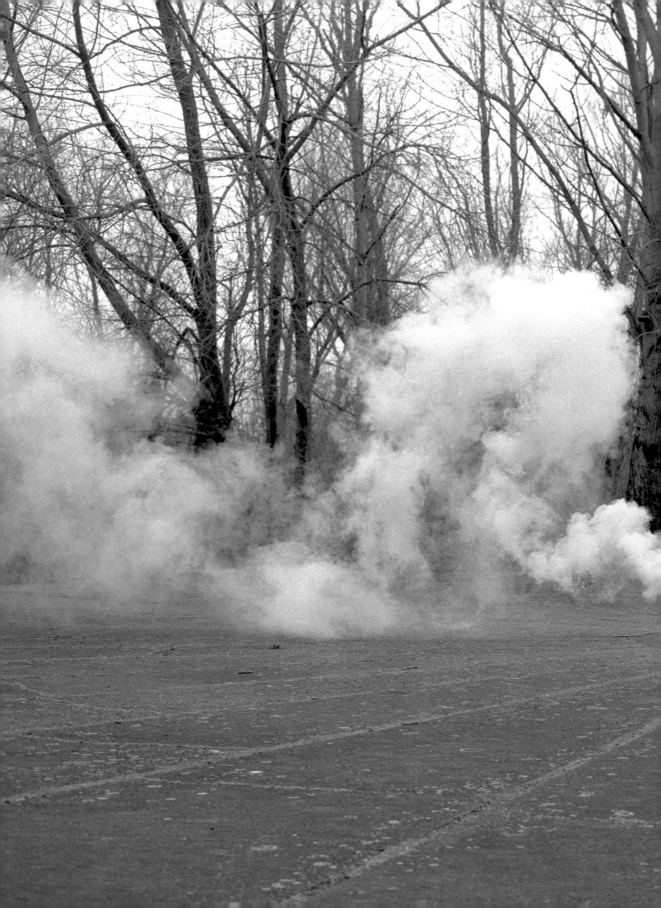

1 toilet roll tube
1 cereal box
46g saltpeter
26g caster sugar
28g candle wax
1 electrical tape
1 fuse
1 match

In Conversation with

Antje Majewski

Antje Majewski: 'Code' doesn't translate well to me because I don't know the context for it. Are you thinking about language? Or algorithms? What is the theory you are referring to?

Originally we were using the word 'Crypt', thinking around cryptography, cryptic and the crypt, a secret hidden place. We are all making work in very different ways, and the title code was selected as whilst being broad in its relationship to translation, all our work has an element of playfulness but also secrecy, which seems fitting to the idea of a code. We feel this is present in both linguistics and algorithms.

AM: Well the code and its translation are both part of the same space; the field of communication. This field is not a road that goes from A to B, passing through to C. It's is a field of possible meanings and connotations (think Wittgenstein's *Sprachspiel*). There can't be one code and one translation. Each code is bound to be slightly different depending on its interpreter and context. The same goes for the translation. This field is a field of cultural forms that we share and participate in making.

Yes, so a code contains a multitude of meanings and interpretations? What possibilities does this open up? Do you think we use codes for the thrill of this? In using a code, we accept that we are providing a space for misinterpretation?

If a code is never decoded is it still a code? We are firing messages into space, the gold disc on Voyager for example, what are they if they are never picked up?

AM: It is very possible that the gold disc is never picked up, or if it is, that communication will fail.

But in this case, I think you're referring to ART. For art there are three possibilities:

A. Artworks communicate with each other.
B. Artworks communicate with other human beings.
C. Artworks communicate directly with the gods (in a secret place).

A. A lot of art that is produced now is a collage, deconstruction or reinterpretation of former artworks (texts, music, architecture, etc.). This can become a rather self-absorbing closed circuit that will appear to be kind of esoteric to the outside world. This way of making art (or curating, or writing) draws its importance from the right reference points. The more obscure they are, the better, because this will make you an expert that can share esoteric knowledge with other select people. It is therefore a way of increasing your importance, by making art based on esoteric reference points. Art here is not a 'language', but a value system that, as Niklas Luhmann has pointed out, has a tendency to *ausdifferenzieren* (becoming increasingly differentiated).[1] This differentiation in itself becomes the goal.

B. Art could also be seen as a field of communication that is essential for human beings. In this case art would step out of the market place, not being about expertise or value; its value would lie in the fact that human beings cannot really live without it. I personally believe in art as a meeting place in a shared space, lets call it the "Distancing Room" (Aby Warburg).[2] We all create this space: living and dead participants, and it also creates us. It is a space in which energies that transverse us are stored. From there we can mould them, using our bodies, into forms that are visible in the physical world. In Aby Warburg's mind, the 'distance' that is essential to this space is culture itself, in any form it might take, including rituals and religious art of all cultures, in its essentiality an extremely important way of keeping the world in balance.

In verbalising or translating the forms of the space of course there can be multiple interpretations of the same content. Warburg gives the example of "pathos formulas" that can be embodied in quite different personae in different cultural sets of symbolic meanings, and still 'be' the same.

I am interested in the work of Édouard Glissant; There is no 'pure' origin, no 'original' truth.[3] But the creole cultures that we participate in fabricating, are wonderful. The multifold, the multitude, the changing and the mutating are all part of the same space.

C. Artworks could also be made to communicate with the gods. In this case again they could be cryptic for human beings, but the maker must be sure that the god or goddess addressed understands and likes them. In most cases these art pieces for the gods therefore belong to a long tradition of secretive, but highly codified objects, ceremonies and rituals, and the maker doesn't have so much agency in their craft. In case you don't belong to any such tradition, or are not initiated, I think its quite risky to make art only for the gods. They might misunderstand...

[1] Luhmann, Niklas, *Die Ausdifferenzierung des Kunstsystems*, Sulgen: Benteli Verlags AG, 1981.

[2] Warburg, Aby, *Der Bilderatlas Mnemosyne. Hrsg. von Martin Warnke und Claudia Brink*, Berlin, 2000.

[3] Glissant, Édouard, *Kultur und Identität, Ansätze zu einer Poetik der Vielheit*, Heidelberg: Verlag Das Wunderhorn, 2005.

Colony

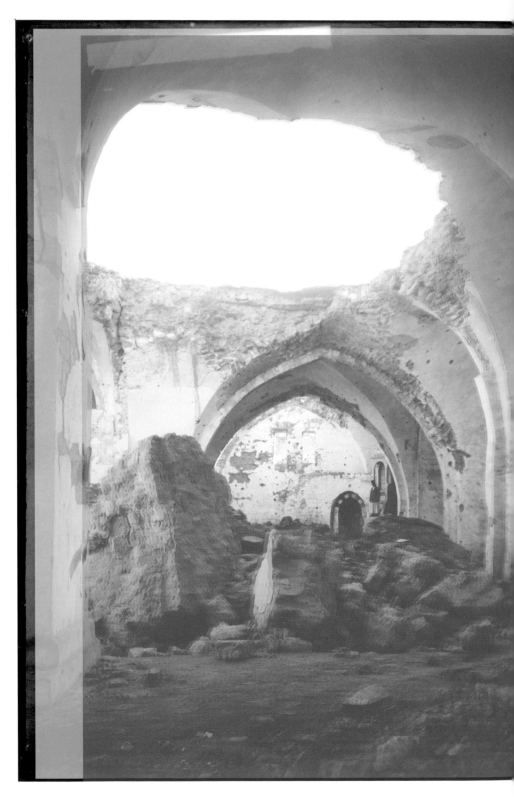

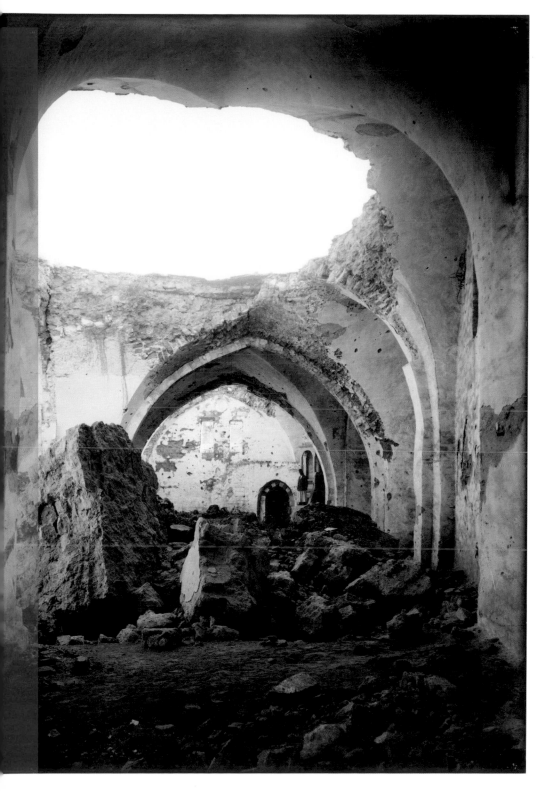

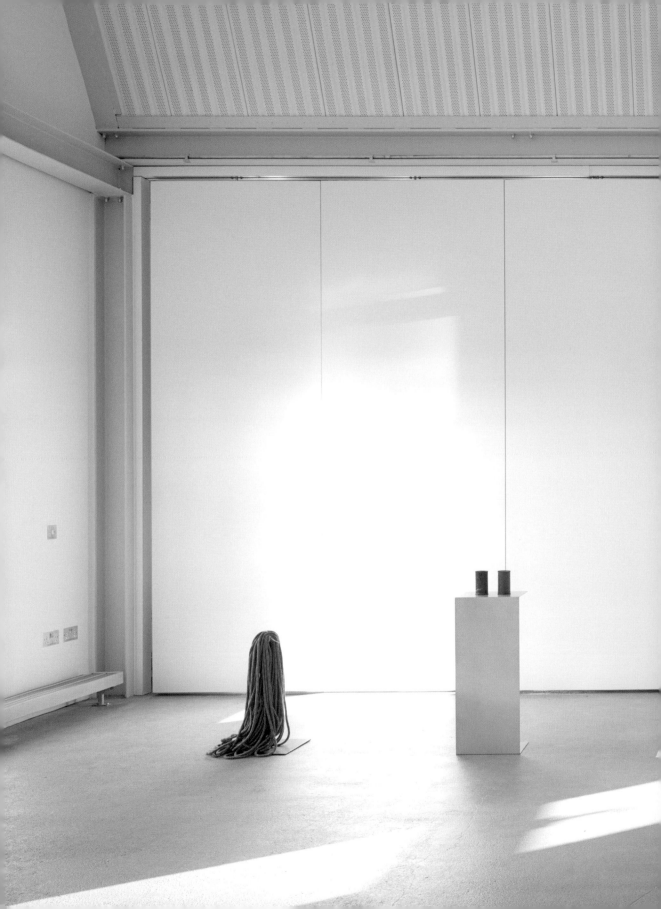

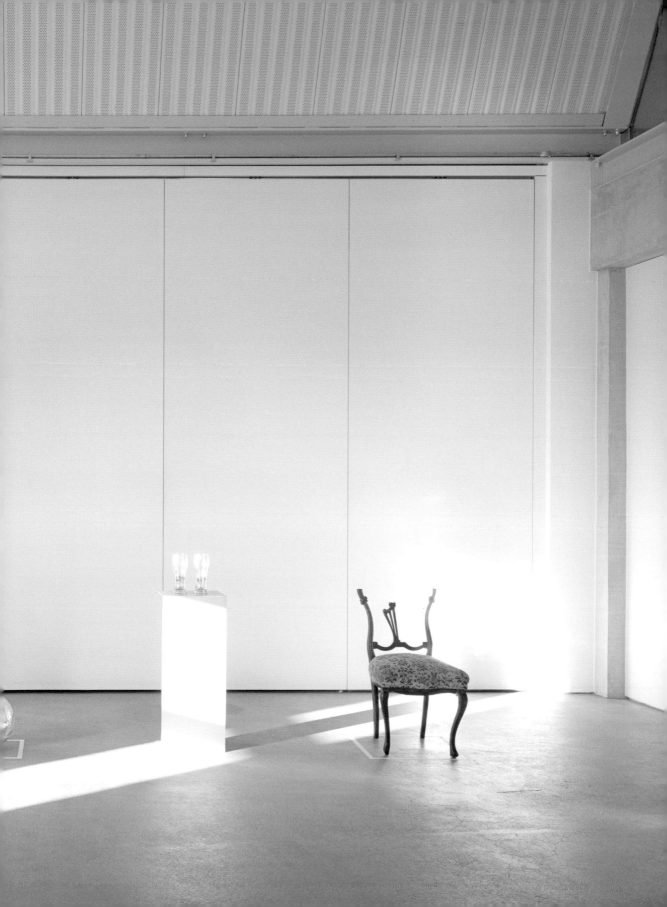

1 *Saucepan.* Manufactured by Le Creuset. Made with cast iron with a wooden handle bar. Found in the kitchen alongside other utensils. Most frequently used for cooking a single portion of grain. Date unknown. *2 Playing cards.* Manufactured by Nintendo. Used for the Japanese equivalent of poker with a few variations. The autumn of 2012. *3 Teapot.* Most likely Nambu ironware produced in Morioka, Japan. Belonged to my deceased grandmother who was known as a tea lover. Handed over after her death in 2009 and used in No.140 since the summer of 2012. *4 Firecrackers.* A series of explosive materials in cylinders. Each of them reads "if found leave in bucket for at least 24 hours". Given by a guest as a souvenir of Lewes, England. 2012. *5 Tins.* In rusted steel. Narrow, triangular openings suggest the residue of liquid contents. Sampled somewhere along Route 66 in Nevada, US. Brought into No.140 alongside my other belongings during the summer of 2012. *6 Matryoshka Dolls.* Found boxed in the basement alongside other belongings of a previous tenant. Additionally used by myself to seal a few exposed negatives since the summer of 2012. Date

1	2	3
4	5	6
7	8	9
10	11	12

unknown. *7 Disco ball.* Originally found in the basement and displaced in the summer of 2012 on garden party occasions. Approximately 35cm across. Date unknown. *8 Variety of cigarette packages.* The countries of origin include America, Indonesia, Iran, Japan, Portugal, to name but a few. Boxed in a Lebanese baklava pastry tin. Date unknown. *9 Whisk.* Made in Bamboo. Initially designed to make a shot of Matcha tea. Served no particular function in No.140 thus considered to be no more than an ornament. The summer of 2012. *10 Georgian styled chair.* Belonged to a previous tenant and heavily used on various occasions until accidentally employed to fuel the barbecue fire in the summer of 2012. *11 Bottle stopper in cork, topped with a silver squirrel figurine.* Donated by an antique dealer in addition to a gun purchased by a current occupier in Naples, Italy. *12 Bib.* Made with a piled cotton fabric and Velcro fastening. Found in the kitchen with a stack of tea towels. Signs of wear indicate its frequent exposure to spills, which is presumably caused by 'messy' food consumption. Belonged to an infant raised in No. 140. Date unknown.

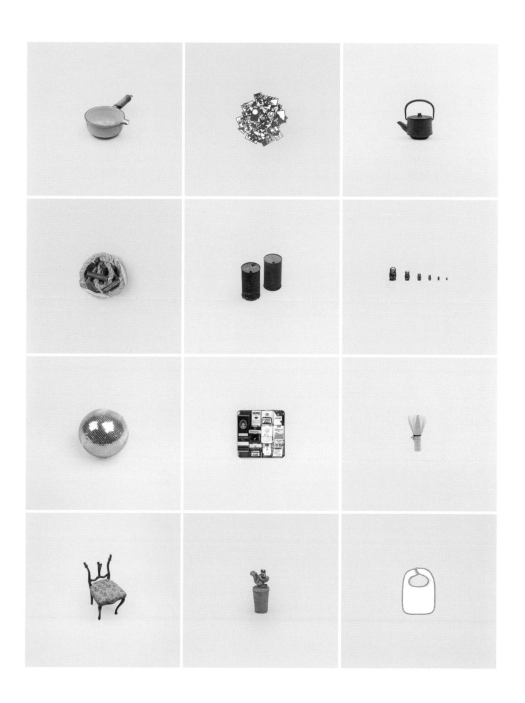

Inventory of 140 Old Ford Road

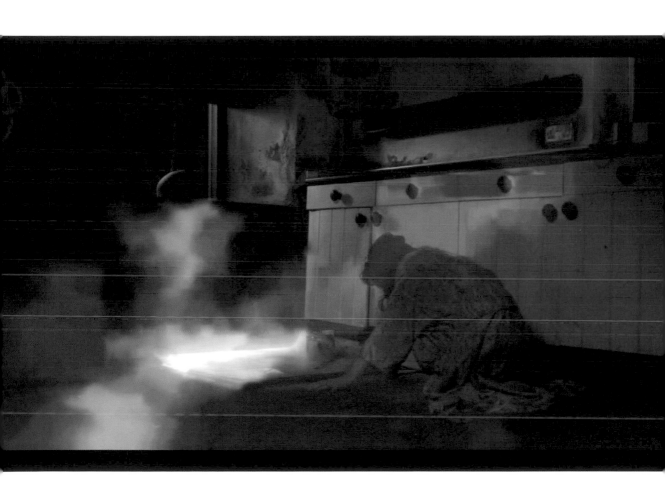

ГУ «Дагестанский музей изобразительных искусств им. П.С. Гамзатовой»

НАУЧНЫЙ ПАСПОРТ

КП № _1818_

Инвентарный № _жс – 103_

Хранительский отдел _зал в IV отсек_

Коллекция _„Живопись"_

Ответственный хранитель _Касимова Б.К._

1. Автор _Васнецов Виктор_
Михайлович (1848 – 1926)

2. Название _„ Птица Гамаюн "_

3. Материал и техника _холст, масло_

4. Размер _214 х 135_

5. Датировка _1898_

6. Сохранность _осыпается краске около рамп._

7. Реставрация _Р – 62 27.04.79г_

8. Время поступления, источник _По приказу мк ДАССР за №165-а_
от 08.08.76. КМЯ передал по акту от 12.01.77г

9. Сведения об авторе _____

10. Участие экспоната в выставке _в Нидерландах Гронинченских_
музей на выставке „Русские сказки"
с 15.12.2007г по 23.03.2008г. в постоян. экоп.

11. Публикации _газеты „Даг правда" от 23.03.09 ст-я „Гамаюн_
птица вещая" Сергеева А.

72

ДАГЕСТАНСКИЙ МУЗЕЙ ИЗОБРАЗИТЕЛЬНЫХ ИСКУССТВ

НАУЧНЫЙ ПАСПОРТ

НАЗВАНИЕ ПРЕДМЕТА

№ ИНВ. КН. *Д-283* *Солонка при-*

Шифр хран. *КП-905* *моральной формы*

ДАТИРОВКА *Дагестан, XIX в.*

Материал и техника *дерево, резьба, краше.*

Размер *28 × 8 × 10 см* | Количество *шт.*

Сохранность *удовлетворительная*

Покупная цена

Откуда, когда поступил и пред. история

Вл. *Мовчан Г.Я.*

In Conversation with

Celine Condorelli

Often, the structures of knowledge production that we are familiar with, such as museums, libraries, study rooms, are rooted or stuck in a pattern of Westernised thought. What happens to those structures when they migrate to another cultural context? And what happens when you, as an artist who deals with those structures of knowledge production, are working in another cultural context? Would you describe this action as translation?

Celine Condorelli: When I work extensively on a project or artwork, questions of continuity arise, building up a line of thought that may persist for three or four years over very different contexts. What is continuous is the development of an idea, as in the case of the series of works "Revisions", for instance, thinking through overlaps and conflicts between art and education, and addressing the pedagogical and the didactic, in short thinking about 'learning' and 'intellectual labour'. But as each project takes place it does so in a particular context, in a set of existing conditions that are spatial, social, economical, political and so on. In each mode of working, while the object in question might be more or less continuous, creating a formal or physical coherence, the organisational structure of the relationship (between the work, myself and the organisation or place I am working with) is fundamentally different, and this is directly manifest in the shifting status of the object, as it moves between different registers. The situations that arise lead to a similar looking object functioning as a sculpture, an office, a shipping container, a reference, an archive, a slide, a subject; this is not the question of using the object as a place holder, an image or an allegory, and it is of no interest to me to consider its faculties of representation. Rather, the object is specifically contingent upon circumstance, and it is invested with different functions in each context and performs accordingly. I think that translation has something to do with this process.

In the case of the piece *Revision—Part 1*, for example, I started from the study, and a painting, *Saint Jerome in his Study*, by Antonello da Messina.

I'll explain:

The *studiolo*—in Italian a diminutive of studio, meaning the study—designates a small private room dedicated to studying, etymologically from the Latin *studium*. It also designates a piece of furniture made for the purpose of writing, very common in sixteenth century Italy. The furniture the word describes could be a table as well as a room, a chest, a cupboard opening up or unfolding into a writing desk, this often containing drawers and other small compartments; it corresponds to the closet as it was known in Elizabethan England.[1] The *studiolo* originates in the monastic world, where monks would seek to practice study, prayer and meditation in absolute solitude and silence.

Petrarca praised solitary life as an essential condition for intellectual activity and for the development of the life of the mind; he is generally attributed for translating this ideal of a contemplative life from the monastic to the secular world.[2] In fifteenth and sixteenth century Italy the *studiolo* emerges as the most secret and protected room in a house, more private than the bedrooms of the time, a small space even in the grandest of palaces reserved for study, writing and meditation, and the keeping of precious books and objects. Indicating both the activity of studying and the space dedicated to it, the term is related in its Latin etymology to the gymnasium, the academy, and the museum—the latter (from the Greek *museion*) originally a sacred space to the Muses, who inspire writers and artists whose works are kept in those very spaces. From here comes a link between museums and libraries, and their common function of conservation —the Muses are also daughters of *Mnemosyne*, goddess of memory. In Italy therefore, the *studiolo* becomes the expression of the humanistic culture of the fifteenth and sixteenth centuries, based on Petrarca's model. Here we start tracing the contours of the intellectual, the scholar as the person who

[1] In England, the closet evolved into the cabinet, more focused on privacy and the keeping of precious objects, and since King George I and his cabinet counsels, into the principal executive group of British government. The closet is a place where one hides things, activities, secrets.

[2] *De vita solitaria* ("of solitary life", usually translated as *The Life of Solitude*), Petrarca, sometime between 1346 and 1356. The philosophical treatise by Italian Renaissance humanist Petrarch is in praise of solitude, and yet is dedicated to his friend Philippe de Cabassoles. Using a personal tone and starting from his own experience, Petrarca exposes a path to happiness consisting in a quiet life in the countryside, away from the distractions of urban life. It is through a life of solitude and contemplation of this nature that philosophers, scholars and saints could develop a higher understanding and thinking. Sadly, solitary confinement is often highly productive for intellectual endeavours, as is testimony the enormously rich literature of works written while in imprisonment. Antonio Negri, while in the prison of Rebbiba, wrote in his preface to *The Savage Anomaly* "I would like, rather, to be able to think that the solitude of this damned cell has proved as prolific as the Spinozian solitude of the optical laboratory." (Originally published as *L'Anomalia selvaggia*, trans. Michael Hardt, Minneapolis: University of Minnesota Press, 1991.)

takes care of things, books, objects, and conserves them for the future, an activity that becomes concretised in the privacy of his study.

This ideal, of a life of quiet study, is a persistent image in relationship to what it is that an intellectual does. But what is this wonderful activity of study? What is specific about intellectual labour, and how to distinguish the life of study from life in the world? What is their relationship? The two lives rely on a division between active life and the *vita contemplativa*, a historical rather than an ontological division, a rupture dating from the Middle Ages that establishes in the Western world the most radical opposition between doing and thinking. Answers I thought could be sought out in the work of a philosopher who separated action from thought and explicated both. *Vita Activa*, the subtitle of Hannah Arendt's *The Human Condition*, is divided into Labour, Work and Action, and the work that follows, *The Life of the Mind*, Arendt's last and unfinished work, was also to be structured in three parts: Thinking, Willing and Judging, the three basic activities of mental life as she saw it, though Arendt passed away having only written the epitaph of the last part. Mary McCarthy, her life-long friend and literary executor writes in the postface:

> Whether or not *The Life of the Mind* is superior to the so-called active life (as antiquity and the Middle Ages had considered) was an issue she [Arendt] never pronounced on in so many words. Yet it would not be too much to say that the last years of her life were consecrated to this work, which she treated as a task laid on her as a vigorously thinking being—the highest she had been called to.[3]

The hierarchy between thinking and doing is not explicit, even though one deduces that thinking is deemed to be a higher activity, but also that it may be something that cannot be talked about, as Arendt keeps quiet. About their relationship she says:

> The principles by which we act, and the criteria by which we judge and conduct our lives depend ultimately on the life of the mind. In short, they depend on the performance of these profitless mental enterprises that yield no results and do 'not endow us directly the power to act' (Heidegger).[4] Absence of thought is indeed a powerful factor in human affairs, statistically speaking the most powerful, not just in the conduct of many but in the conduct of all.[5]

The life of the mind, in that sense, is what allows one to know, judge and decide how to live in the world, at least some of the time. Thinking therefore

[3] McCarthy, Mary ed., *The Life of the Mind*, New York: Harcourt Brace Jovanovich, 1978.

[4] Lovitt, William ed. & trans., *Martin Heidigger, Age of the World Picture*, 1938.

[5] Arendt, Hannah, "Invisibility and withdrawal", in, *The Life of the Mind*, New York: Harcourt Brace Jovanovich, 1978, p. 71.

is fundamental to action in allowing one to determine how to act, and it is in its absence that incomprehensible things happen. In order to assess what thoughtless action carries for Arendt, it is enough to refer to her primary motivation for writing *The Life of the Mind* in the first place, that being her attending Eichmann's trial in Jerusalem. It was in composing her work *The Banality of Evil*, that Arendt addressed the incomprehensible relationship between the monstrosity of deeds and an absence of motives, a relationship that reflected not stupidity, but thoughtlessness. The question that arose was whether the activity of thinking was one of the pre-requisites to abstain from evil-doing, and in this case, what constitutes thinking and how is it used.

Thinking is what occurs in the life of the mind, and that which allows us to act in the world. The life of study is dedicated to the potential of action, to how to do.

You once mentioned the idea of the gift as a strategy for power and domination. Can you elaborate on this in relation to art and colonialism?

CC: I've thought about gifts in their relationship to support, which is one of the principal notions I've been exploring through my practice. Mark Cousins, in a text he wrote for "Support Structures" distinguishes support from generosity in this way:Support is not a form of generosity. Generosity is without reserve, but remains a gesture by a generous subject to a needy subject, which is what structures the relation between the two. Because the generous subject is giving more, perhaps, than even justice demands, which, of course, means that it is not and cannot be an act of justice, but a will to give: "I am giving you this because I want to." In this way, generosity unfortunately brings in its train all these terrible things like gratitude and dependency. We just need to think of Potlach societies, who wage war not with physical violence, but by giving gifts, and in doing so create debt and gratitude, or just confusion. What these show us is that generosity cannot be the basis of a social relation, but produces a continuous relation between the donor and the recipient. What is so important about support, on the other hand, is that it is a politically defined field rather than an ethically defined one. [6]

[6] Condorelli, Celine, Mark Cousins, "Support Structures", in *Afterall*, 24, summer 2010.

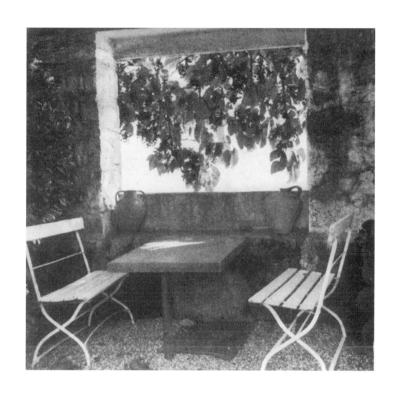

Cuckoo

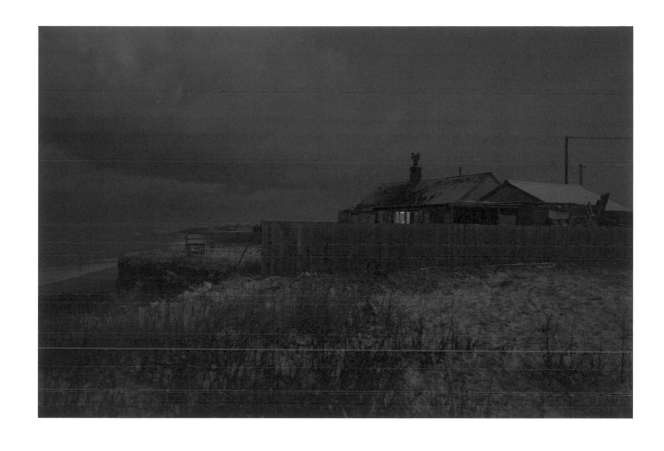

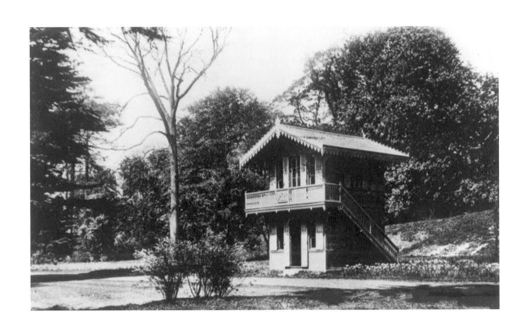

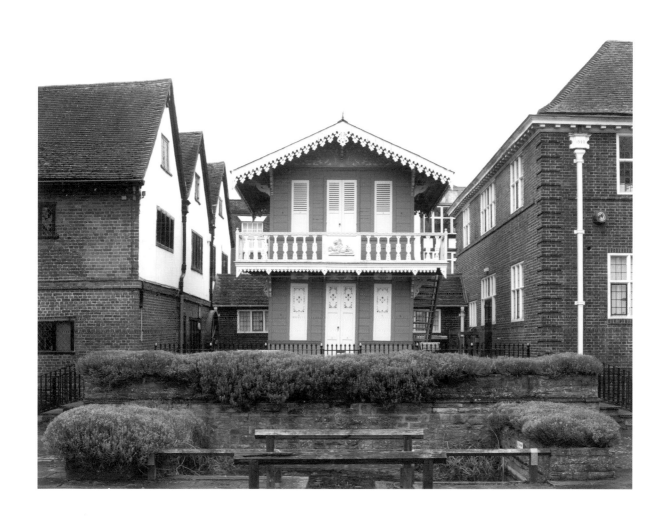

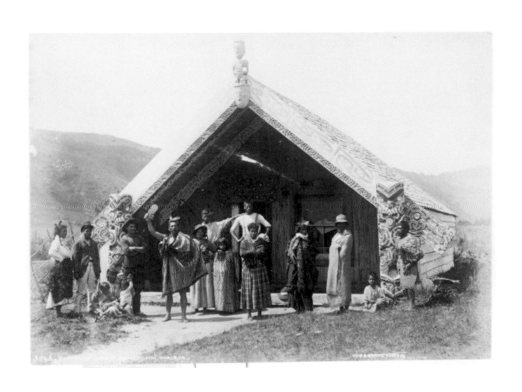

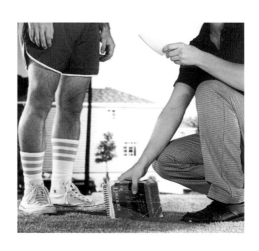

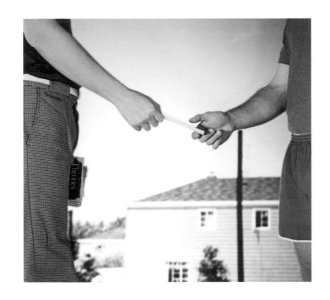

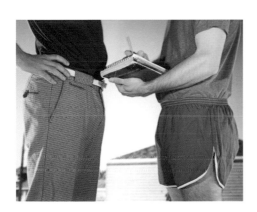

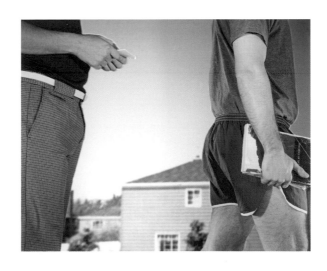

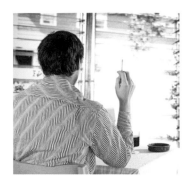

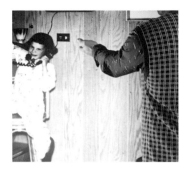

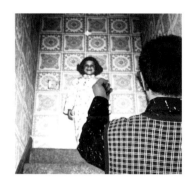

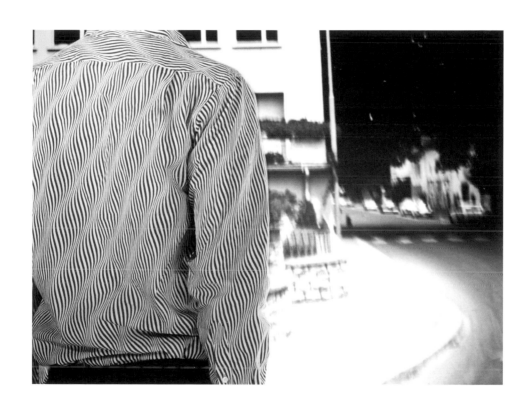

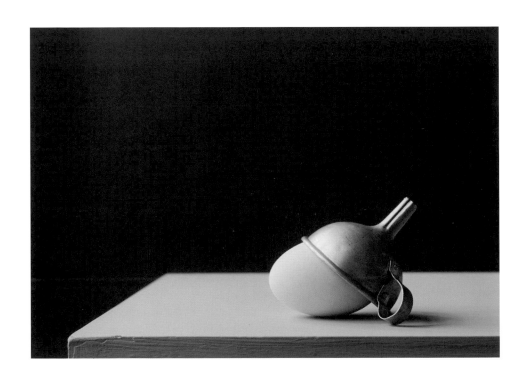

Cuckoo

Olivier Richon

The cuckoo's song is monotonous and repetitive. This bird gave its name to a clock with a very special mechanism. The door of a miniature alpine chalet opens, a mechanical bird comes out, sings its song and goes in again every quarter of an hour. Two metal pine kernels are the weights that set into motion the clockwork. We all remember Orson Welles deriding the cuckoo clock in *The Third Man*. This mechanical invention is reduced to an emblem of stagnation and Swiss safety. It repeats, it is reliable; the bird comes in and out.

Watch the birdie, *le petit oiseau va sortir*, used to be the warning the photographer would utter, a command to keep still. The camera becomes a cuckoo clock of sorts, it marks time. In French, *oiseau* also refers to the penis, and the trousers' fly is called a *pigeonnier*, a pigeon house. In this respect, the traditional role of the photographer as voyeur is reversed: to take a photograph is an exhibitionist act, it is to display one's bird. And if the bird is a cuckoo, one should not be surprised if it comes out of a *pigeonnier*, as these birds are known to drop their eggs in other birds' nests.

The Common Cuckoo lays eggs in other birds' nests, and her eggs imitate the appearance of the host's eggs. Some cuckoos are polyandrous; they mate with more than one male. Natural history here gives us a narrative about imitation and promiscuity. In cultural history, the egg is polysemic and ambivalent. Christian and Pagan. It belongs to the repertoire of the carnival, licentious amusement and sexual excess. The egg is a recurring sign in Brueghel, Bosch and others. It is an aphrodisiac; the fool breaks eggs; witches lay eggs and cross the water in an empty eggshell; two eggshells and a sausage are depicted in Jan Steen's feast of the epiphany; the devil thrusts a knife into an egg, letting the liquid flow into his arse; you do not make an omelette without breaking eggs. Centuries later, Georges Bataille's *Story of the Eye*, is primarily the story of eggs as sexual and metaphorical objects. Notoriously, Salvador Dali comes out of a giant egg containing milk, blood and a symbolic fish on the shores of his native Figueres. There is madness in the egg.

The egg as sign has travelled through centuries of image making and is still present today in puns, plays on words, allusions and metaphors. *Qui vole un oeuf vole a boeuf.*

The egg has also its place in early photography. The albumen prints of the 1850s used egg whites to stick the chemicals on the surface of the paper, leaving a surplus of egg yolks to be used in the kitchen; Louis Désiré Blanquart-Evrard was the first to exploit albumen prints commercially. The women in his factory in Lille printed Maxime du Camp's archeological photographs of Egypt, Nubia, Palestine and Syria. Viewers would ecstatically consume the fine tones of the image printed on thin paper.

Like the cuckoo photography repeats; and in the manner of sticky egg whites, it binds visual signs together. Yet the repetitive and mechanical function of the camera does not produce sameness. Imitation is also transformation. It is a form of translation. The example of the cuckoo as a producer of auditory signs, dropping eggs in strangers' nests, eggs that imitate other eggs is probably a bit of a twisted metaphor, where natural history becomes visual history. And yet representations of nature translate into fiction and fantasy effortlessly, as in one of Hieronymus Bosch's pictures:

The field has eyes, the forest has ears, and I will see, be silent and hear.

Translation forms and deforms. It is betrayal and invention. One does not make an omelette without breaking eggs, or without putting one's foot in it.

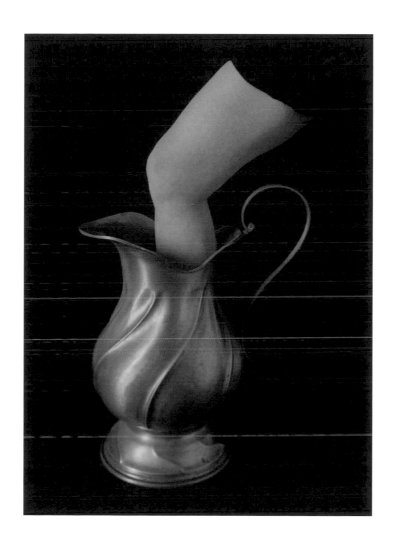

Gebrochene Akkorde

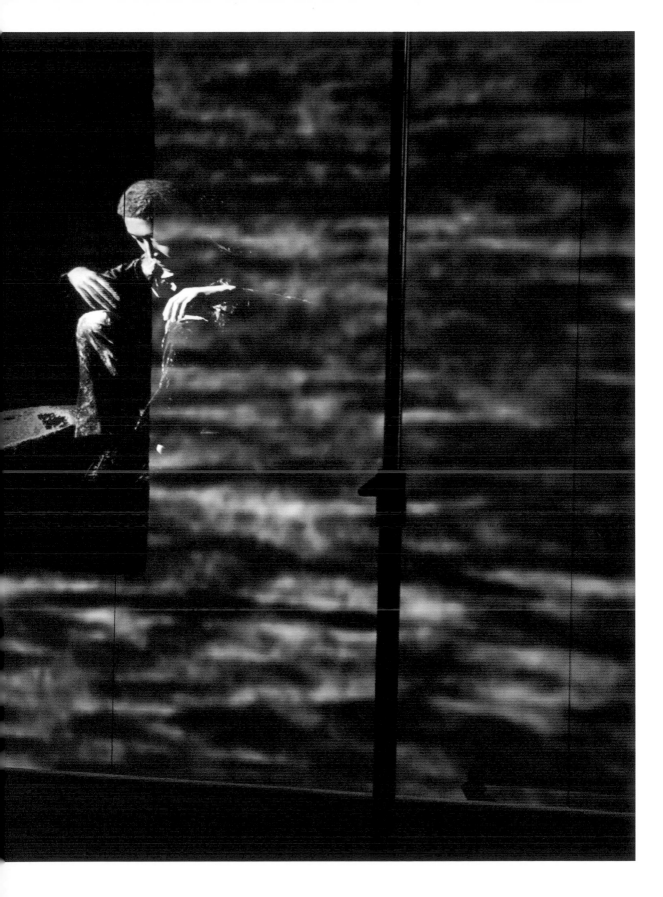

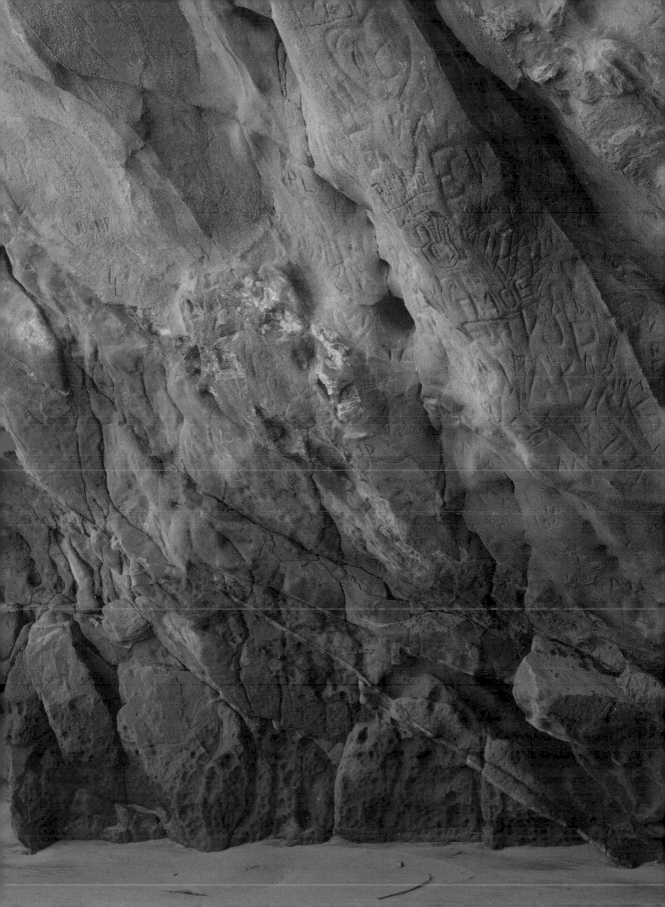

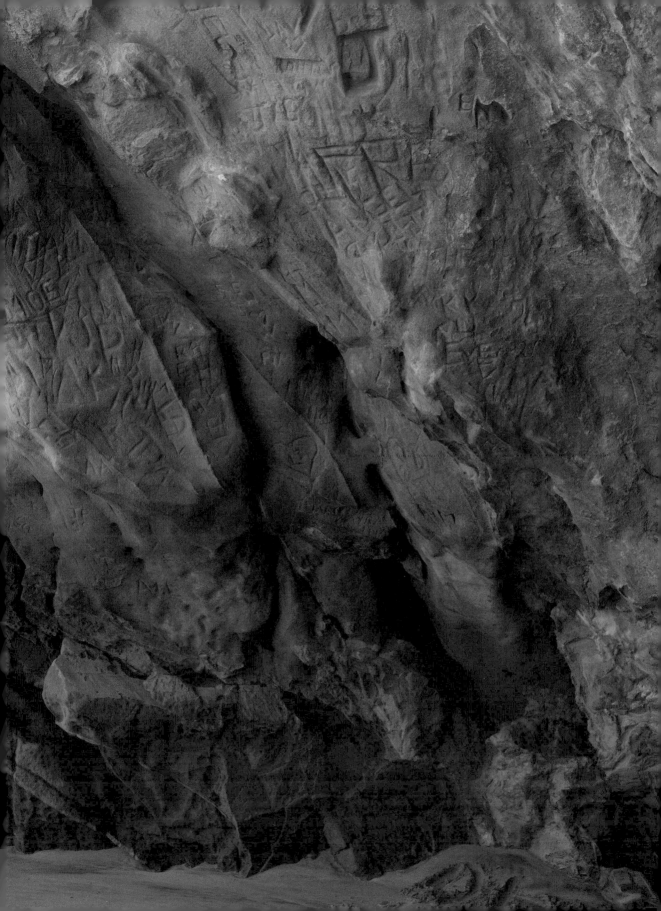

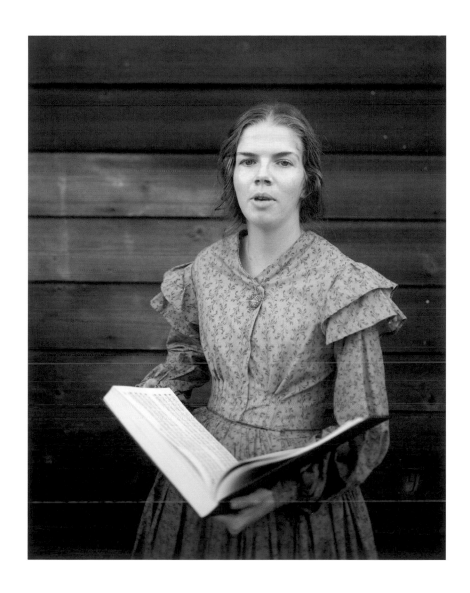

Gebrochene Akkorde

Alexander García Düttmann

Brechen, in German, suggests some violence done, as in gebrochenes Herz, or broken heart, while Akkord tends to be understood as something to do with a harmonious relationship or resonance. When the Frenchman wishes to express his agreement idiomatically, he says d'accord. Hence what is striking about the meaning of the musical expression gebrochener Akkord is that it does not refer to a violence that would interrupt the simultaneity of a harmonious relationship or resonance, or that would interfere with different notes that agree with each other so intimately that the ear can no longer tell them apart. On the contrary, the broken chord merely unfolds and explains in the fluid element of a coherent sequence what otherwise suspends and sublates the discrete individuality of a single note. If we translate, if we allow the gebrochener Akkord to transport us from music to the image, would an image then appear as a condensation and concentration of a series of images concatenated so as to become invisible, or even, in the ideal case of all possible images concurring and converging, so as to create an image of pure light and pure darkness? In other words, does the gebrochener Akkord, assuming it allows us to move from one to the other, reveal cinematography as the truth of photography and photography as the truth of cinematography? When Jonas Mekas makes his diary films, using footage of the everyday over a more or less indefinite period of time, assembling extended sequences in quick motion but also sequences reduced almost to stills, and stills transpiring through moving images, is he aiming at capturing the image of life? The translation effected by a gebrochener Akkord confronts the photographer with a similar yet different medium, the medium of cinema. Perhaps the question he must then ask himself is what it is that prevents photography from being simply the truth of cinematography, or what it is that disrupts the transport system employed. To see a photograph that could never be a still, to see a still that could never be a photograph, that's the challenge that the gebrochener Akkord poses, the challenge of translation. Translation has already begun and come to an end, a broken heart, a broken leg.

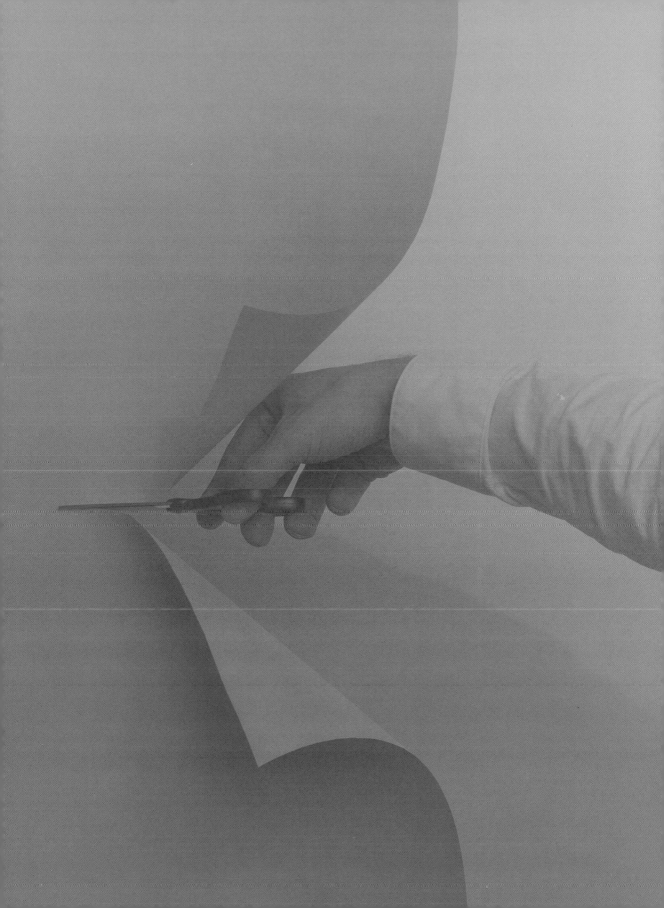

Waving Flags

Nick Warner

Semaphore is a system of communication that combines handheld flags and choreographed movements to convey information from one person to another, over large distances. Semaphore flags are most commonly used in maritime and seafaring, but also in remote landscapes such as mountainous areas, where electronic or oral communication is not possible. The flags are held in a series of fixed positions that represent the letters of a codified alphabet. Semaphore signaling does not in itself necessitate the use of flags, but flags make the individual characters much easier for the receiving party to distinguish. Equally, flags as communication tools are not exclusive to semaphore flag signaling, but can carry a message or meaning in their design, colouration or shape; waving a white flag is a universal sign of surrender, and waving a red flag is an indication of danger.

The notion of waving flags is one that inherently suggests a translation of information from one party to another, via a system of basic visual signification. It can be a way of pledging loyalty or allegiance to that which the flag represents. It can be nationalistic, or a protest, or as with semaphores it can become a language in itself. Artistic practice becomes a comparable process of design, performance, signification and interpretation all enacted through translation, not only between people, but across the lateral span of multiple languages, codes and cultural systems. Our interaction on a daily basis is mediated by images, and is comparable to the value that can be inscribed in the design on a flag or sign. However, the layers of complexity that art practice instills in such a system of representation brings artistic production much closer to semaphore, whereby the system of signification is developed into an autonomous language; instead of communicating through visual data supported by the flag, the supporting system becomes the signification in itself. Continuing this reading raises the questions, is it necessary for an audience to be initiated? As with semaphore, is there a language of contemporary art that one must learn before one can interpret the message of the artist? If so does this language change from practice to practice? Or does it universally change and evolve over time, as with the vogues of contemporary art?

Recently, artist David Raymond Conroy mentioned to me that he felt complicit with a vogue proliferating in object making arts practice that I propose could probably be attributed, in some capacity, to the increased significance of screens in contemporary life. This vogue was the practice of producing sculptures that are inherently two-dimensional, or at least have an intended front, and an intended back. Conroy is of a generation whose formative and thus primary experience of the world was pre-digital, and so his is a slightly different case in that his own inclination towards the two-dimensional harks back to a training in the photographic—a craft that is heavily immersed in all things flat. For others, however, this increased interest in two-dimensionality seems symptomatic of an era in which we transpose physicality into the virtual, and interact with it via *surface*. The ways in which we understand images and objects is increasingly governed by the screen; interactivity has become a pre-requisite and interface a global dialect.

This notion of the screen dominates and so our navigation of experience becomes increasingly photographic. Our understanding of the world is mediated through the image now, with the Debordian notion of spectacle— "A social relationship between people mediated by images"—more profound in the context of the virtual and web 2.0 than it ever was as a critique of capitalism and mass media. Where pre-digital developments in mass media triggered a new societal engagement with representation and a greater individual susceptibility to the image, the post-digital (for want of a more eloquent binary) has triggered a specifically *interactive* engagement with the previously static notion of the image.

Through the process of interface and the dominant language of interactivity photographs, in their association with the digital, have taken on a different *objectness*. Photography is typically the ethereal non-media, existing in the space between the eye and the thing, the window through which we gaze back at a subject that may no longer exist. Photographs exist as an interruption of physics, somehow harmoniously transcending both time and space, yet in complete cooperation, in fact support, of their parameters. When printed on paper the photograph is an object, and takes on a materiality, yet one of such frailty and insignificance that it borders on immaterial; only a scientist would describe a sheet of paper as three-dimensional. Paradoxically, it is in their translation to the screen that photographs have taken on this increased *objectness*. We no longer use such apparent apparatus to enlarge, crop, rotate and retouch our images. We do it with our digits, sliding them in choreographed gestures over the surface of our touch screens, clicking and dragging, pulling and poking; an entire language of practiced gestures. This gradual translation from subject into object presents entirely different relationships with the image, relationships that are, again, governed by interface.

The tactility of print instills a different interactivity to that of a screen, and an intimacy with the image occurs that can rarely osmosise through that weighty membrane of pixels and Perspex. What is clear is that these

different modes of representational presence grant the image varying agencies as cultural signifier. Through the traditions carried by print, or through the physical associations carried by the digital image the implication of the signal, the image or the subject fluctuates in meaning, remaining consistent only in intent; an effort towards translation and this notion of interface persists universally through the interactivity of interpretation. As with the implication of a system of codified semaphore transmitted through flag waving, the information, the code, the data, remains embedded only in an image, something visual that carries known meaning, but the data becomes animated and effective through *enactment*, as a pre-digital mode of interface or interactivity. It is the practice of artists and those working with art to propagate the development of these visual signifiers into the more complex language of signification. As with the waving of a flag, the enactment can simply be a display of the flag which bears its own signifier, or it can be the gesture of waving itself that becomes significant.

List of Works

CAST

Elisabeth Molin
www.elisabethmolin.com
molin.elisabeth@gmail.com

8-9 *Red-Eye*
Colour sourced
from red eye
2013

10-11 *Nightguard*
Colour photograph
2013

Patrick Hough
www.patrickhough.com
info@patrickhough.com

13 *Object Interviews*
Digital C-Type print
2013

14-15 *Fission*
Digital C-Type print
2013

Joanna Piotrowska
www.joannapiotrowska.com
joanna.piotrowska@network.rca.ac.uk

17 *Untitled (from FROWST)*
Silver gelatin print
2012

18 *Untitled*
Silver gelatin print
2012

19 *Untitled*
Silver gelatin print
2012

Masayo Matsuda
www.masayomatsuda.com
masayo.matsuda@network.rca.ac.uk

21 *Untitled (from He won't
love me because he knows
what I did)*
Photogram
Silver gelatin print
2013

23 *Untitled (from He won't
love me because he knows
what I did)*
Silver gelatin print
2013

Clare Bottomley
www.clarebottomley.co.uk
clarebottomley@live.co.uk

 Station of the Cross
24 *I, IV*
25 *II, XI*
26-27 *XII, VIII*
Silver gelatin prints
2013

Emily Butler

33 *Andrei Rublev,
Christ as Saviour*
c. 1410

CODE

Abigail Sidebotham
www.abigailsidebotham.com
abigail.sidebotham@network.rca.ac.uk

36-37 *Untitled*
 C-Type print
 2013

38 *Sappers Wanted!*
 Poster from Web Campaign
 sapperswanted.co.uk
 2013

39 *AZc(hut) 3 Nose Fuze*
 C-Type print
 2013

Emma Charles
www.emma-charles.com
mail@emma-charles.com

40 *Exchange #I*
 C-Type print
 2013

41-42 *Algorithm*
 C-Type print
 2013

43 *Exchange #II*
 C-Type print
 2013

Victoria Jenkins
www.victoria-jenkins.co.uk
victoria.jenkins@hotmail.co.uk

44-45 *Griffin*
 Silver gelatin prints
 2013

46-47 *Hippocampus*
 Silver gelatin prints
 2013

Julio Galeote
www.juliogaleote.es
julio_galeote@hotmail.com

48-49 *Untitled (from the
 series Excess)*
 Digital C-Type print
 2013

50-51 *Untitled (from the
 series Excess)*
 Digital C-Type print
 2013

Geoff Bartholomew
www.geoffbartholomew.co.uk
geoffbartholomew14@gmail.com

52-55 *Strike Gently*
 Mixed media
 2013

COLONY

Michal Bar-Or
michalibar@gmail.com

60-61 *Ruins at Gaza,
 Stereograph (From the
 American Colony archive)*
 Archival pigment print
 2013

62-63 *Collection of rules
 (From the Palestine
 Exploration Found
 archive, 1902-1905)*
 Archival pigment print
 2013

Madoka Furuhashi
www.madokafuruhashi.com
info@madokafuruhashi.com

64-65 *Inventory of 140
 Old Ford Road*
 Digital C-Type prints
 2012

66-67 *Inventory of 140*
 Old Ford Road
 Mixed media installation
 2012

Simone Rowat
www.simonerowat.co.uk
simone.rowat@network.rca.ac.uk

68-71 *Fluid Corruption (stills from)*
 HD Video
 2013

Taus Makhacheva
taus.makhacheva@gmail.com

72-75 *Way of an object*
 Mixed media
 2013
 (Courtesy of Garage Centre
 for Contemporary Culture)

Celine Condorelli

81 *Study after Le Corbusier*
 2011

CUCKOO

Ryan Moule
www.ryanmoule.com
ryan.moule@network.rca.ac.uk

85 *Fractured Isle*
 Silver gelatin print
 2013

86-87 *Open Surface*
 Silver gelatin print
 2013

Louise Carreck
www.louisecarreck.com
louise_carreck@hotmail.co.uk

88 © *Dickens chalet at*
 Gad's Hill Place (Courtesy
 of Museum Strauhof)

89 *Swiss Chalet*
 Giclee Print
 2013

90 © Burton Brothers
 (Dunedin, N.Z.) Burton
 Brothers, 1868-1898 (Firm,
 Dunedin): *Photograph of*
 Hinemihi meeting house,
 Te Wairoa. Ref: PA7-19-19.
 Alexander Turnbull
 Library, Wellington,
 New Zealand.

91 *Hinemihi, Maori*
 Meeting House
 Giclee Print
 2013

Oezden Yorulmaz
www.oz-yo.com
info@oz-yo.com

92-95 *Ed and Jack*
 Digital C-Type prints
 2013

Olivier Richon

96 *Spiritual Exercise*
 C-Type print
 2012

99 *The Temptation*
 of Saint Antony
 C-Type print
 2013

GEBROCHENE AKKORDE

Shengjie Gao
gaoshengjie.co.uk
shengjie.gao@network.rca.ac.uk

102-103 *Forté project*
 Video installation
 2013

104 *Forté project*
Film still
2013

105 *Sound compose for*
Forté project
Hand written
notes on paper
2013

Beth Atkinson
www.bethatkinson.co.uk
beth.atkinson@network.rca.ac.uk

106 *Shape Note Singer*
(Maggie), Poway,
California
C-Type print
2013

107-108 *Sea Cave, Corona*
Del Mar, California
C-Type print
2013

109 *Shape Note Singer*
(Stephanie), Poway,
California
C-Type Print
2013

Andrew Bruce
www.brucebruce.co.uk
info@brucebruce.co.uk

110 *Birds in Flight (5)*
C-Type print
2012

112 *Birds in Flight (7)*
C-Type print
2013

113 *Birds in Flight (9)*
C-Type print
2013

Philipp Dorl
www.philippdorl.de
contact@philippdorl.de

114 *Colour gradient,*
dark grey, horizontal
Black and white
laser print-out
2013

117 *Slit Backdrop I*
Photograph
2013

119 *Slit Backdrop II*
Photograph
2013

COVER IMAGE

Ryan Moule

— *Brother*
35mm Slide
2012

Colophon

Waving Flags is published by
Black Dog Publishing Limited
10A Acton Street
WC1X 9NG
London
United Kingdom
blackdogonline.com

Edited by
Rut Blees Luxemburg
Nick Warner

Editorial team
Ryan Moule
Beth Atkinson

Waving Flags follows on from *Seeing for Others*, ISBN 978 1 907317 62 0 and *Hardcover: Image Perspectives,* ISBN 978 1 907317 41 5, the previous titles published in an ongoing collaboration between Black Dog Publishing Limited and the Royal College of Art's MA Photography Programme.

ISBN 978 1 908966 10 0

In association with
Royal College of Art
Kensington Gore,
SW7 2EU
London,
United Kingdom
rca.ac.uk

Thanks to
The staff of the Photography Programme at the Royal College of Art: Professor Olivier Richon, Hermione Wiltshire, Peter Kennard, Sarah Jones, Rut Blees Luxemburg, Yve Lomax, Francette Pacteau, Susan Butler, Alexander García Düttmann, Stuart Croft, Nigel Rolfe, Lewin St Cyr, Jan Naraine, Simon Ward, Kam Raoofi, George Duck, Roddy Canas, Michael Turco and the Dean of Fine Art, Uta Meta Bauer.

Royal College of Art
Postgraduate Art and Design

reuse recycle reduce

www.blackdogonline.com

art design fashion history photography theory and things

black dog publishing
london uk